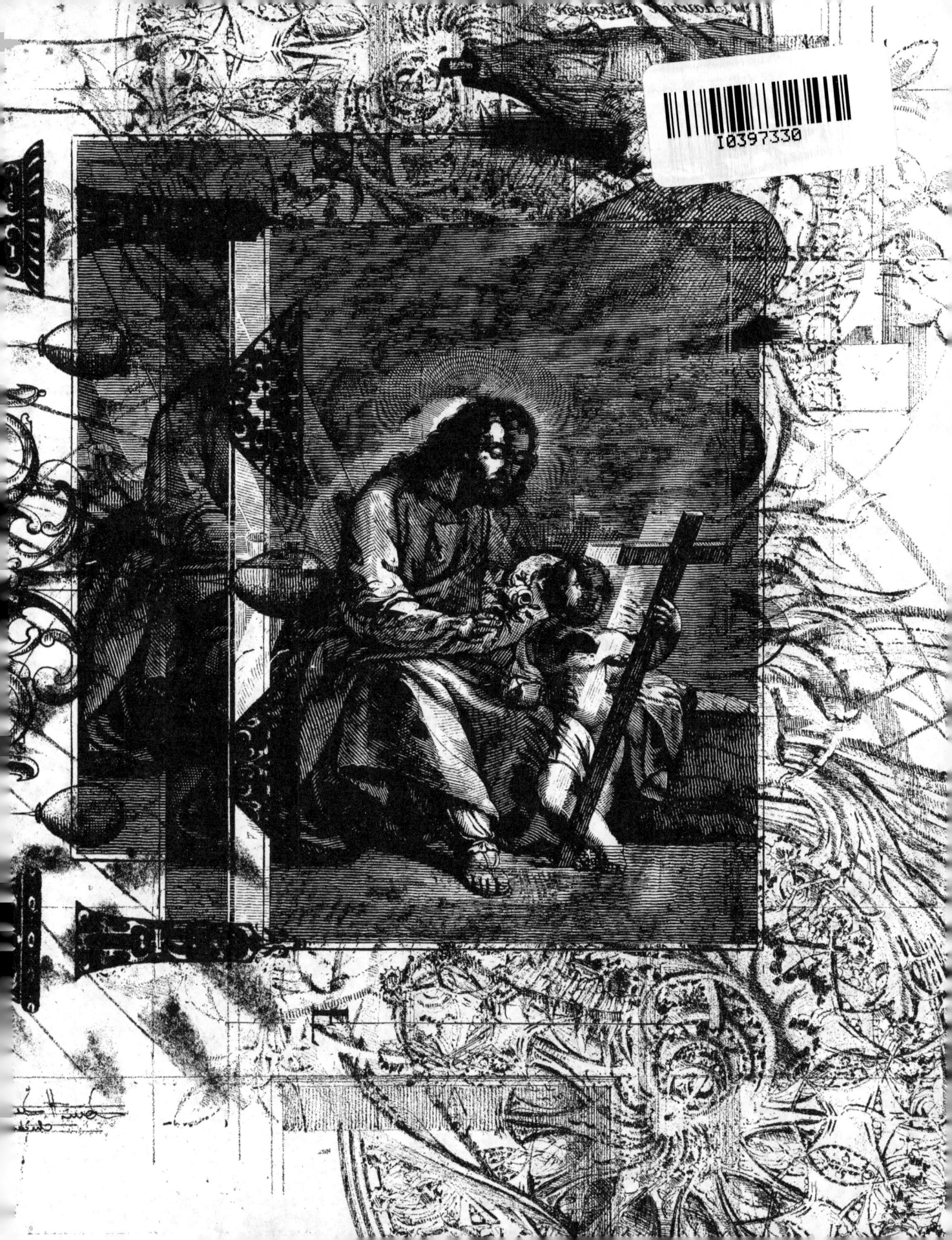

Polit

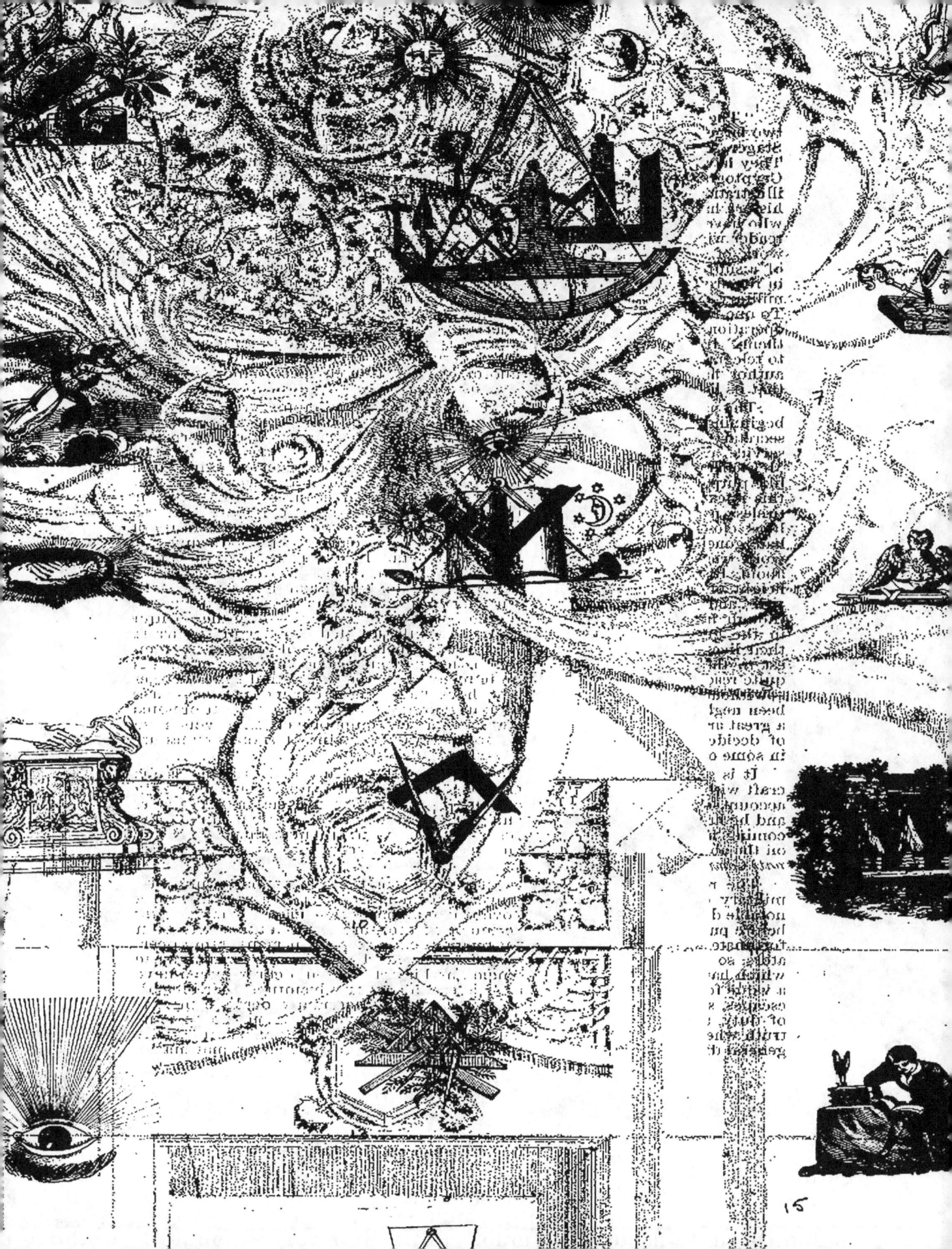

(text is mirrored/reversed, reading as best as possible)

...record of the ser... performed by the telegraphers is arranged... departments and interwoven with a narrative of the war, and some dispatches which passed over the military wires—many of them never published—are given in the course of the story. The author has been ...in obtaining the personal reminiscences of a ...army officers ...that his book abounds in incidents of a variety of camp... ...he has ...ked a chronicler, and is not without details which have ...on the military history... He tells of daring adventures, hair-breadth sufferings cheerful... captivity, starvation and death in the line and he leav... us in no doubt that Secretary Stanton told only the ...al report. "The Military Telegraph under the ...rection of Colonel Stager and Major Eckert, has been of inestimable

The narrative of adventure is the most pleasing form of literary expression, and this is as well illustrated in this book as in any of its kind. It is now, of late, as it has been of yore, a way of telling a story about the rich life which humanity weaves through all manner of fascinating, quaint, or picturesque scenes. How the story of this life is excessively interesting is seen in the pages that have been written and published by those who have been for this warm and absorbing task during the last few years. There is now a growing list of books that deal with this kind of writing, but none of them can perhaps be an interesting illustration of how to build a good story out of the ordinary materials of the workaday world. The present little book is a very modest but most delightful example of its kind. Like the writings of travelers and others who have recorded their wanderings by moor and field, it is partly a record and partly the setting forth in pictorial form, as it were, of the journey itself — its events and happenings, with this slight difference that more than any other it is a very much more, and this is all that it purports to be, and the author of these services is not charging with the administration of the government by any organised party. If there has been brought out in this work, it is, very truly, the sources and tendencies of the...

[text largely illegible due to heavy ink/image overlay]

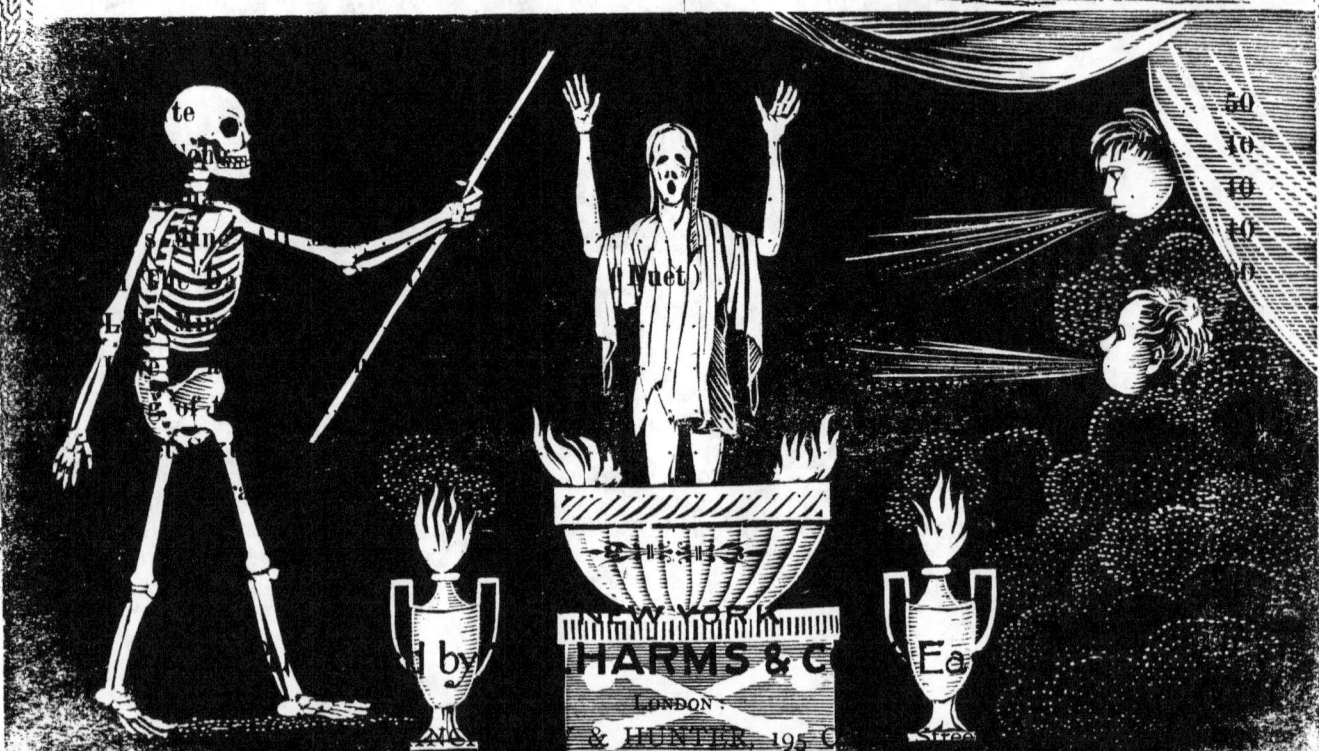

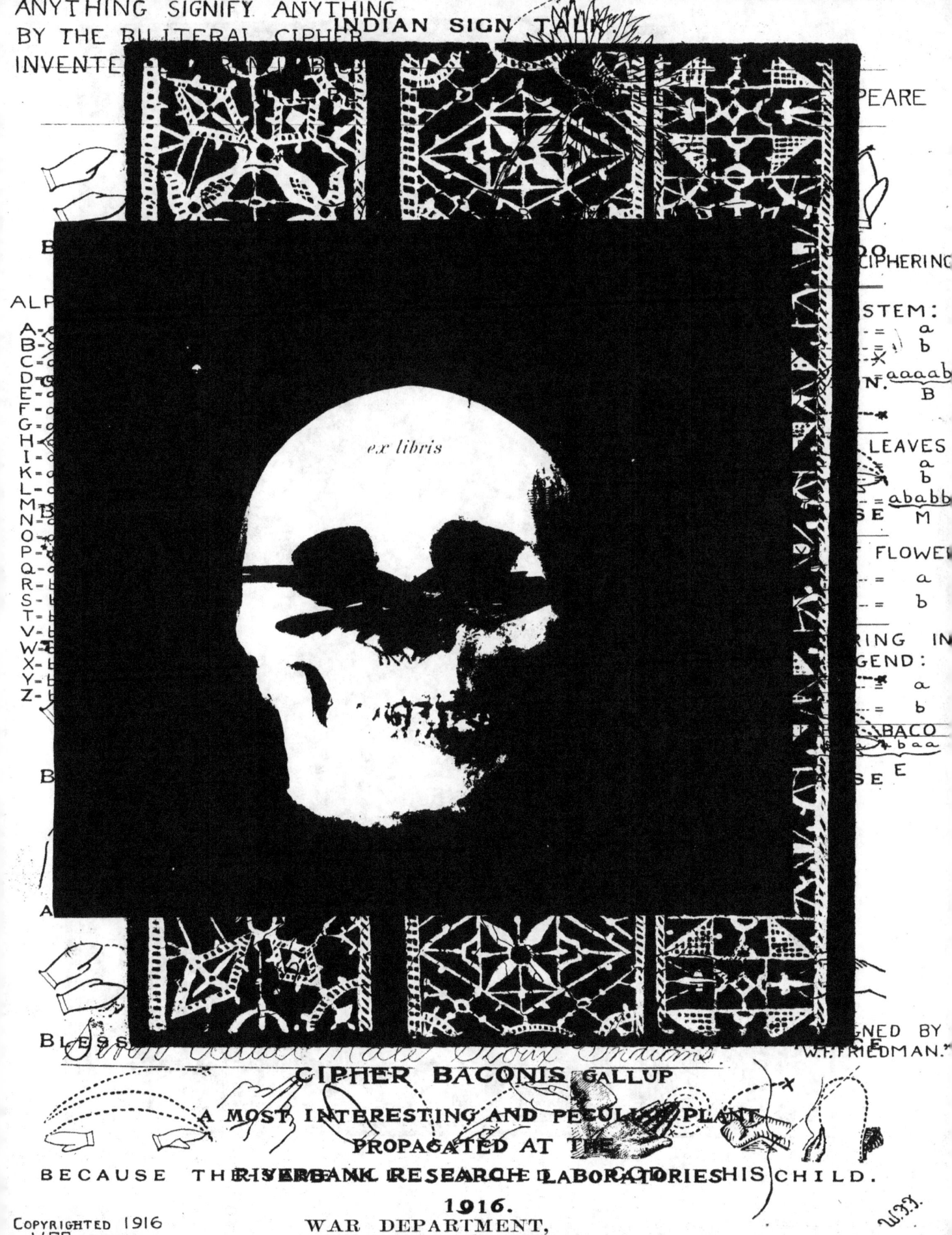

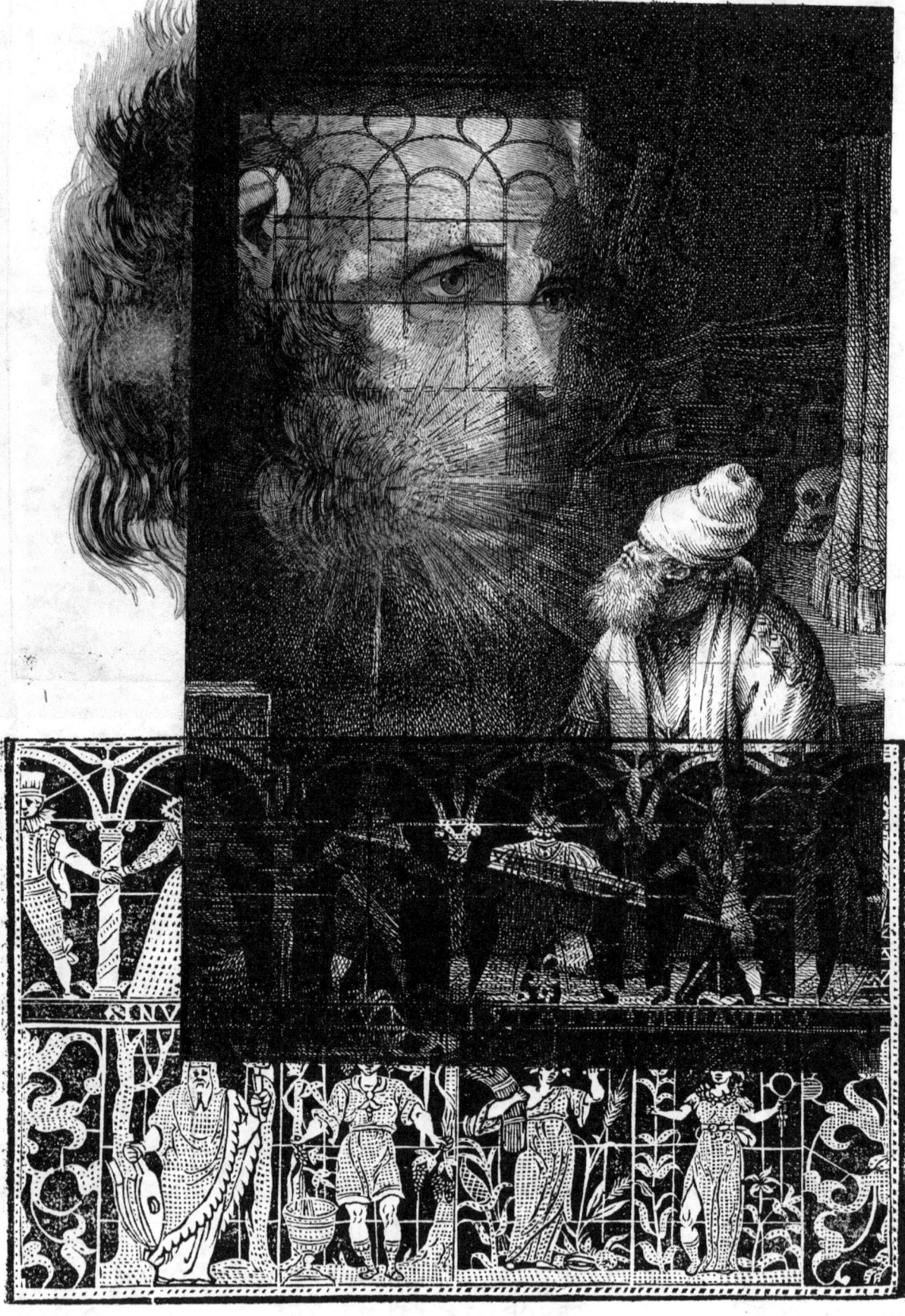

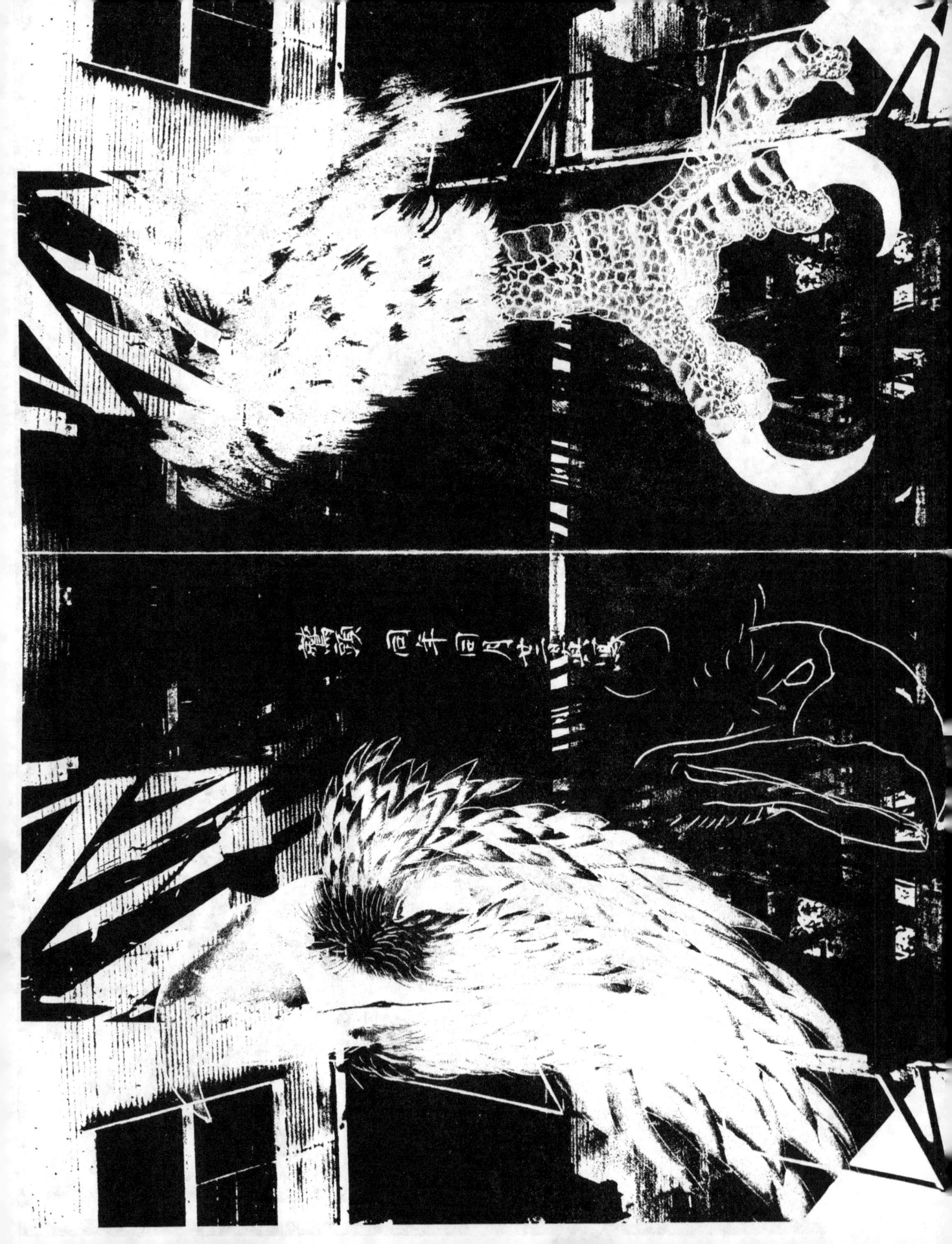

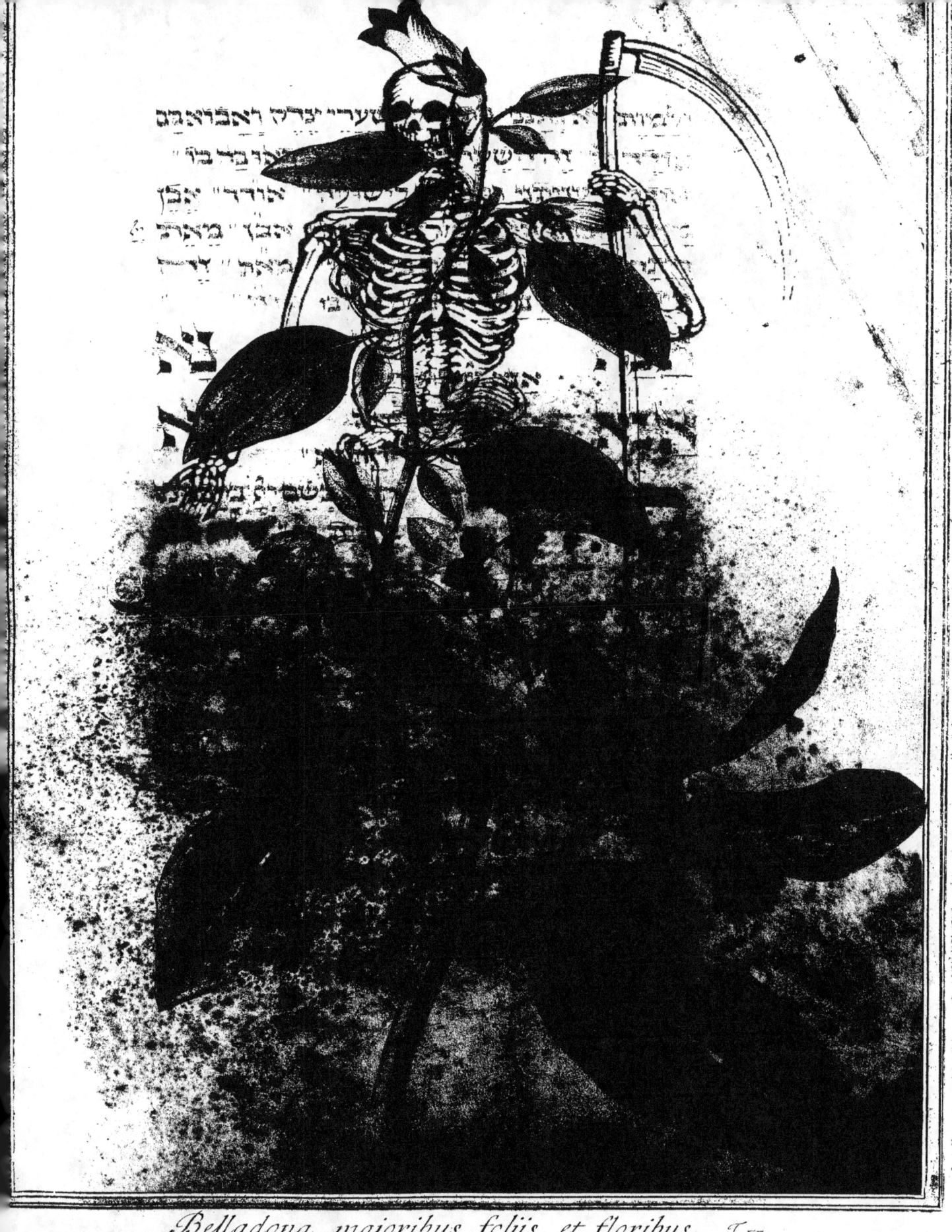

Belladona, majoribus foliis, et floribus. T. 77.
Ital. Belladonna. — Gall. Belladone

Showing the cross-bisected rituals through the of the central sun and the interior continents and

Praefectus magnus

rear view

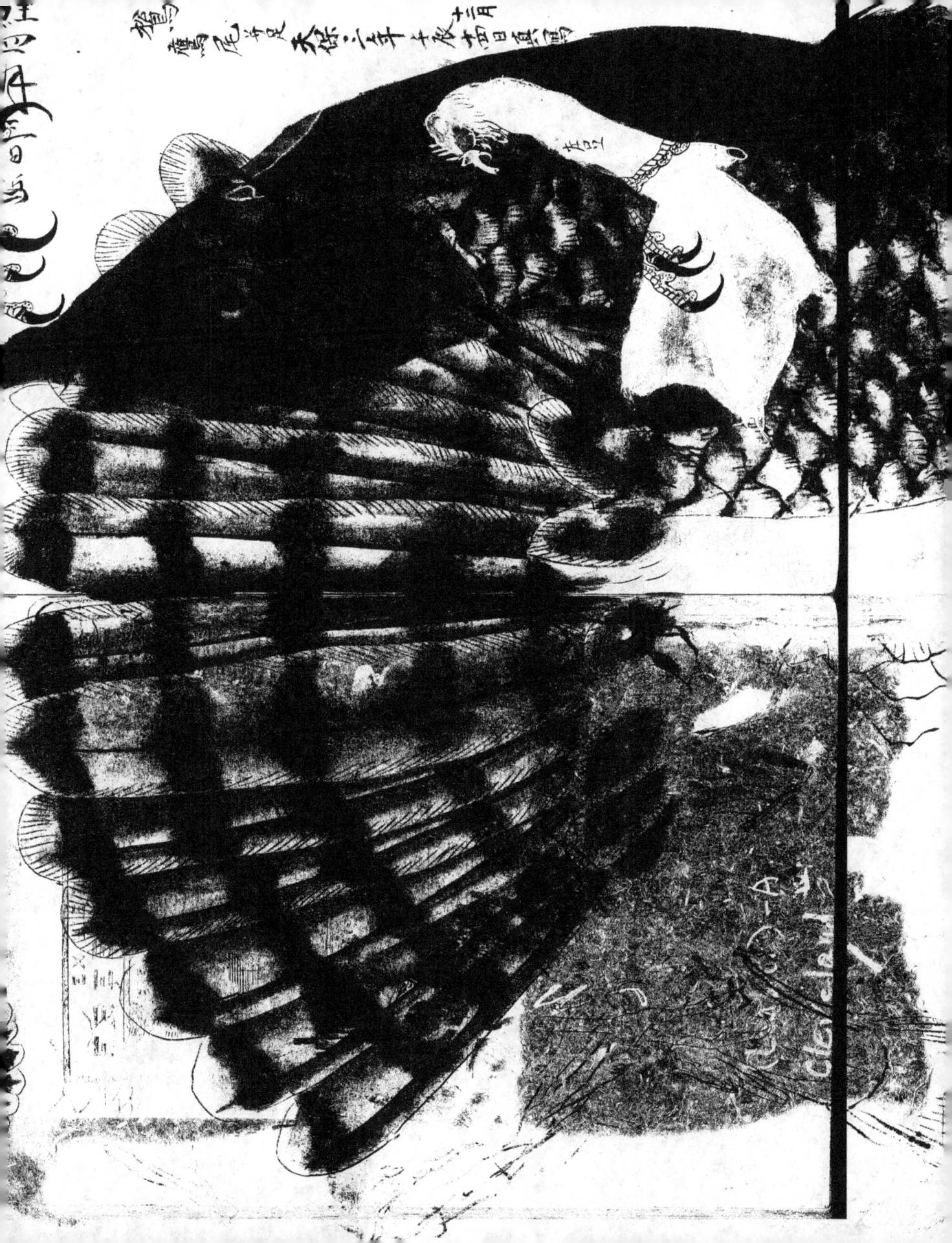

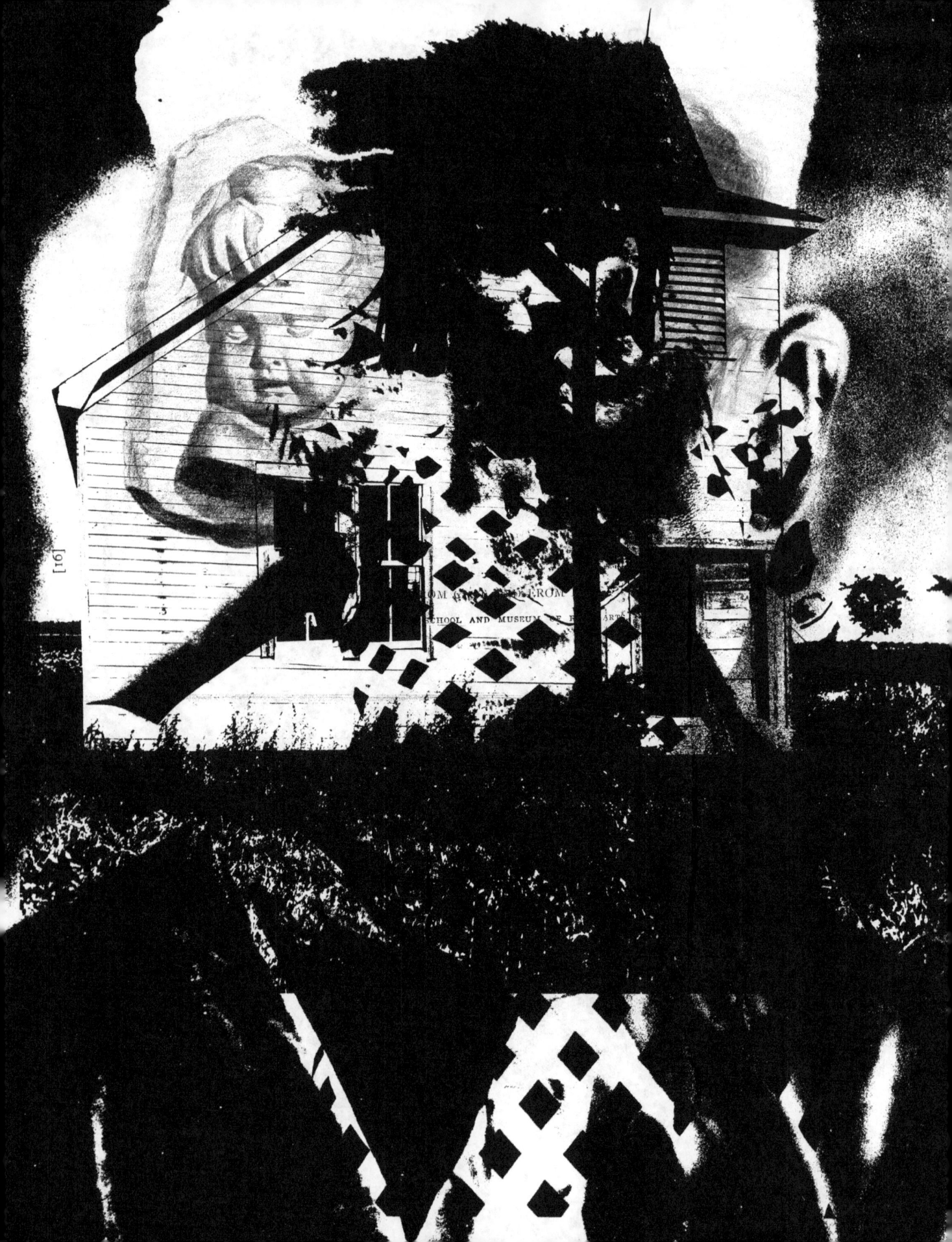

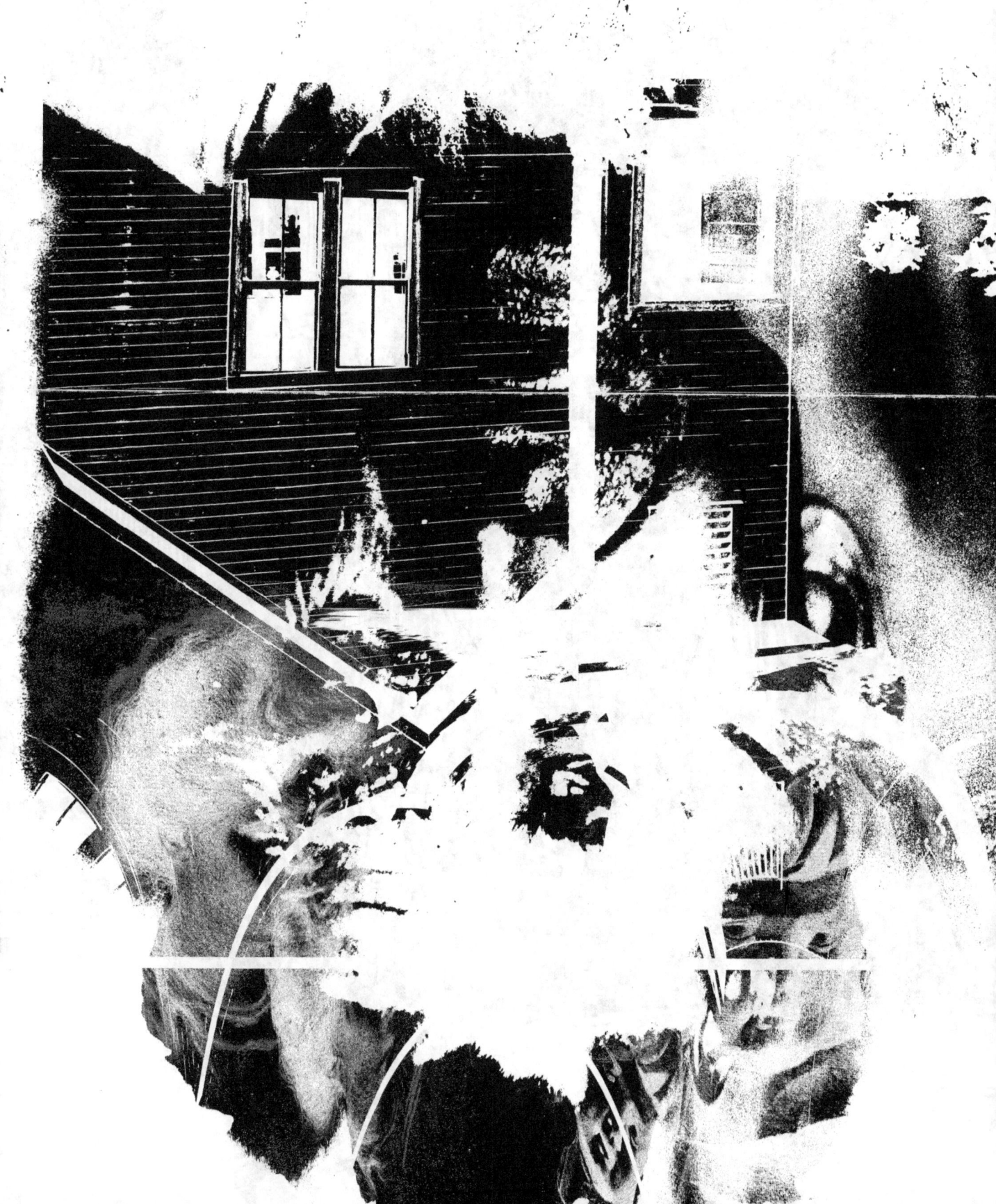

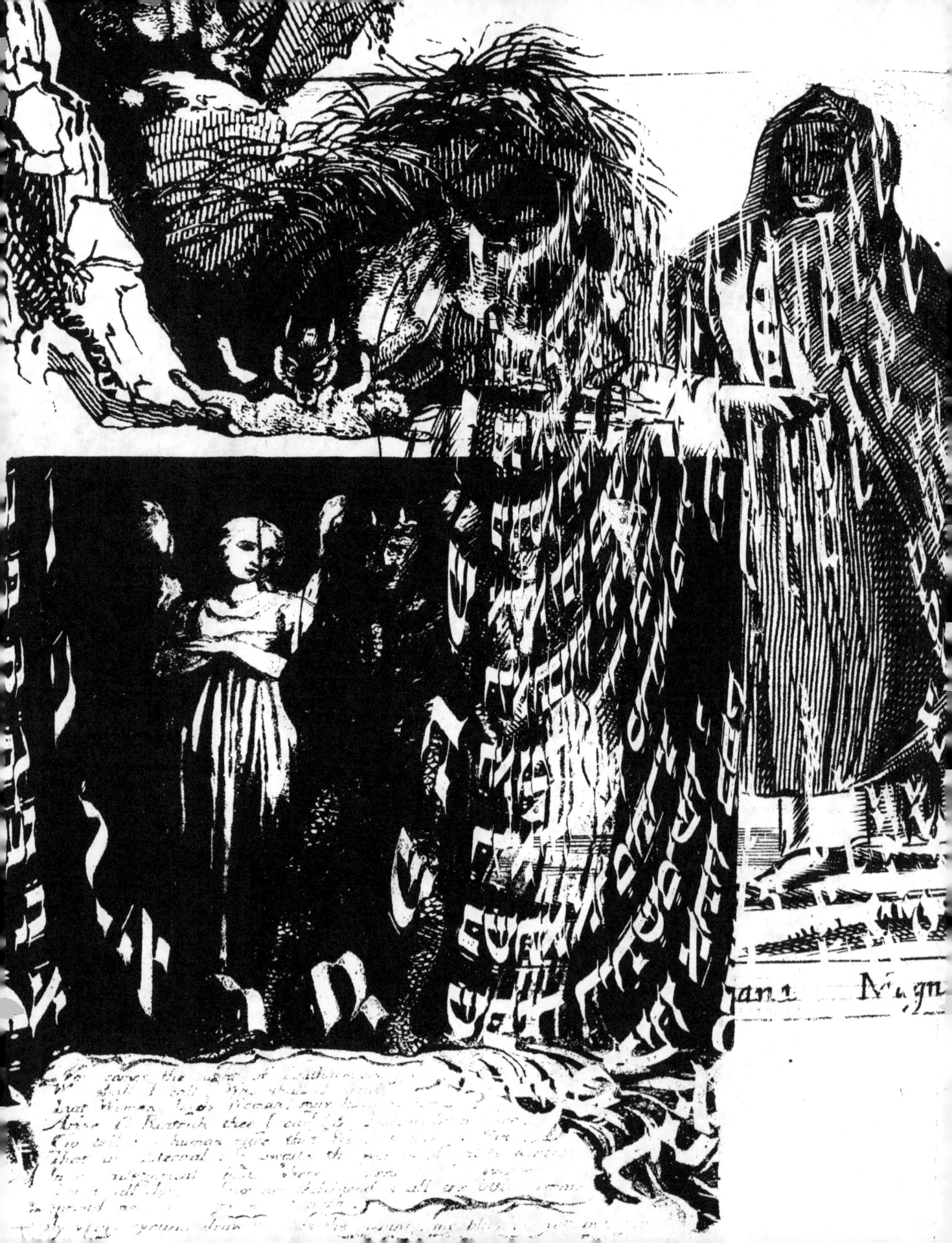

ק רְּבִידִי וְלֹא שָׁנִי
כִּי פֵּירָא בְּקִיצֵיהּ
ר בִּרְכֵי אַשְׁלֵי יַרְעֵי הֲלַךְ
כִּי בִּרְסָא, רִינְקוּ
אִילְּעָא לְכוּ בְּמִסְּוָ
וְלֹא אֲבוּוֹן יָתֵי בְּבָיִי
תּ וְלֹא גַּמְרָא, רִידִי זְמִיר
ת וְלֹא הִלְּכוּ סְרָחֵא מִיל
בְּשַׁתָּא אוֹ מַתְרִיץ
שַׁפִּיר רִיתַּשְׁמִיעוּן
רִיתַּשְׁמִיעוּ אֲחָד בְּפַק

In the upper a
graph operation
literature
narrati
ings in
erious
about
Callan, at Chumbai, and does not
pose, into the enormous
exceedingly i
manners of
cloe ... rew together the
one ... and ha
wa ... during the trial seven
R ... packer
... at dizzy hea
tion ... ad tran
... the ... are still
in their ... daily and in
... general reader than any ... quiet more, is of
id to say nothing with the indi ... of the vol the
d which ... could not have been ... he author th
jected by ... own mental di ...
t arrive at comparative ... new facts a ...
sided ... imagine the scenes
ng of the ... of the war—theingi
is surprising ...
with easy ... he ide ... a ... riv years
the ... a ... de telegr
has ... itch work ... be invalu
historic ... bellion
ability and thoro ... s of this ... able addition to history.

e record of the ser ... performed by the telegraphers is arranged
by departments and interwoven with a narrative of the war, and some
atches which passed over the military wires—many of them never
blished—are given in the course of the story. The author has been
... in obtaining the personal reminiscences of a ... army ope
that ... his book ... a variety of camp ... p in
... acked a chronicler, and is not without details which have
... e for the military histori... He tells of daring adventures, hair-breadth
s, sufferings cheerfull ... captivity, starvation and death in the line
... and the leav ... us in no doubt that Secretary Stanton told only the
n ... al report: "The Military Telegraph under the
direction of Colonel Stager and Major Ecker has been of inestimable

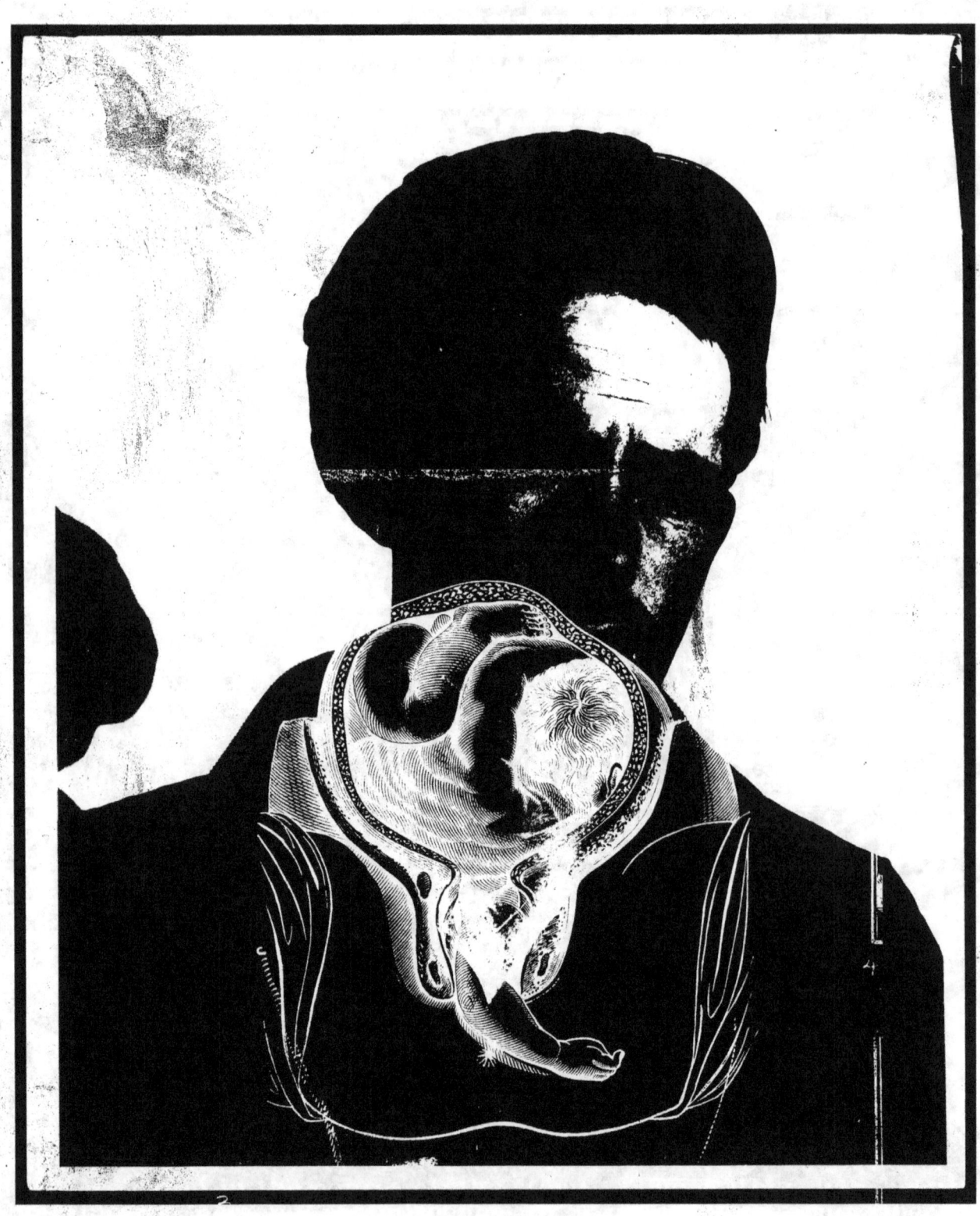

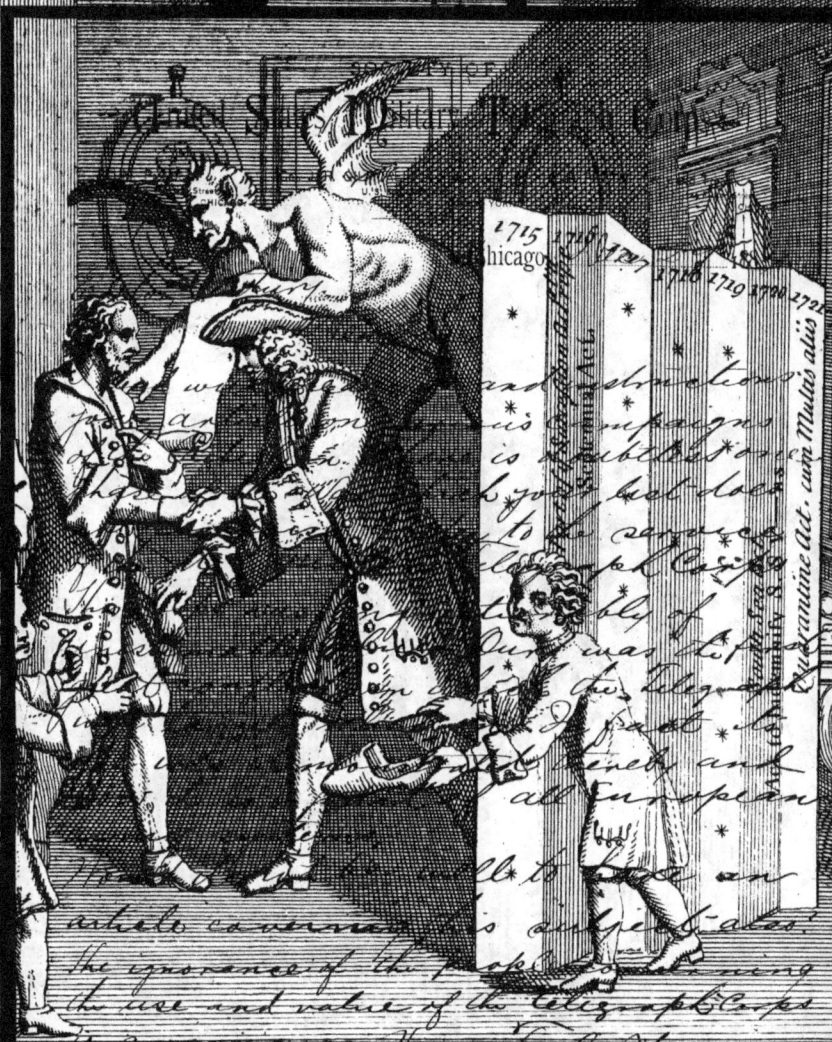

The prevailing Candidate, or the ELECTION carried by Bribery and the Devil.

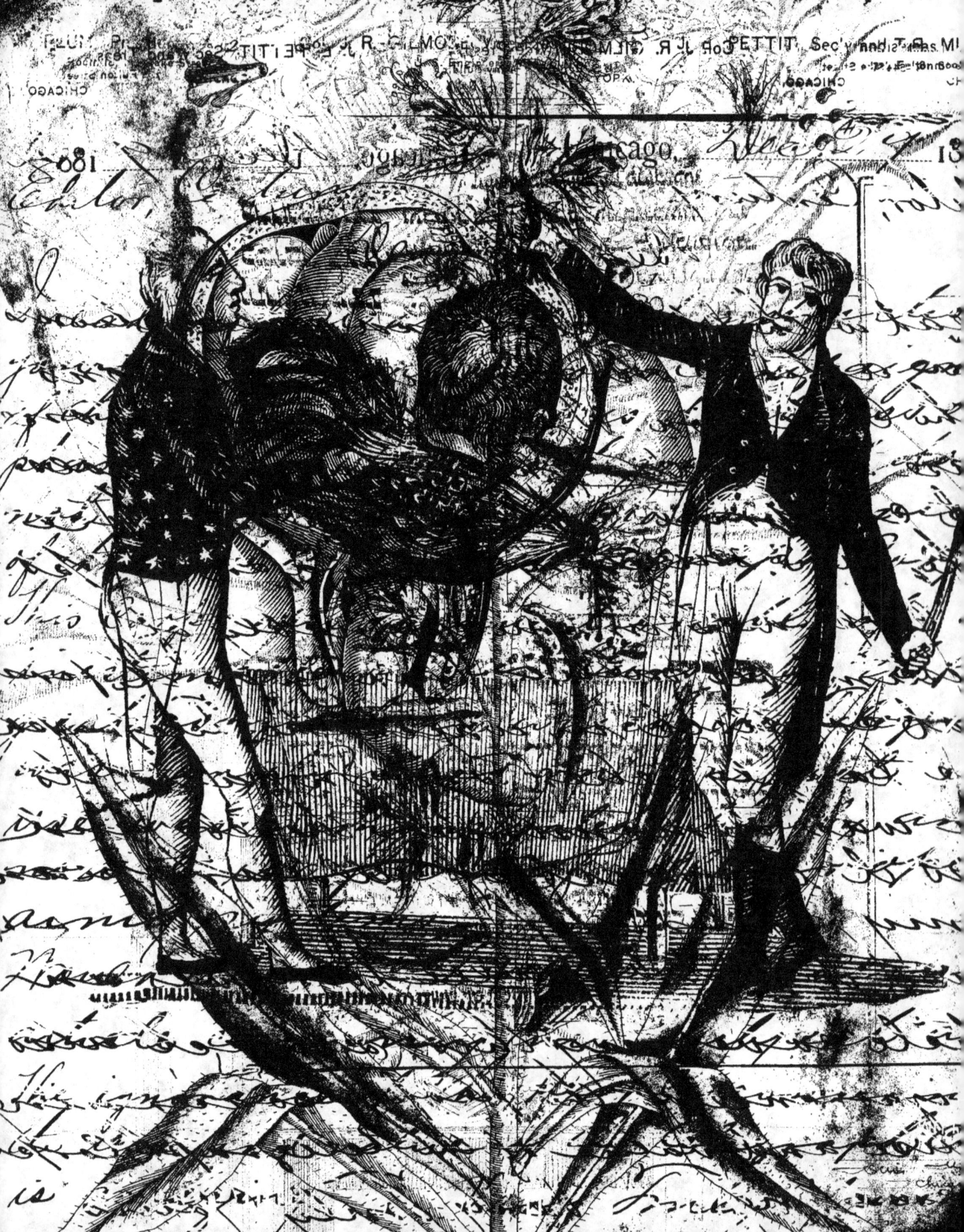

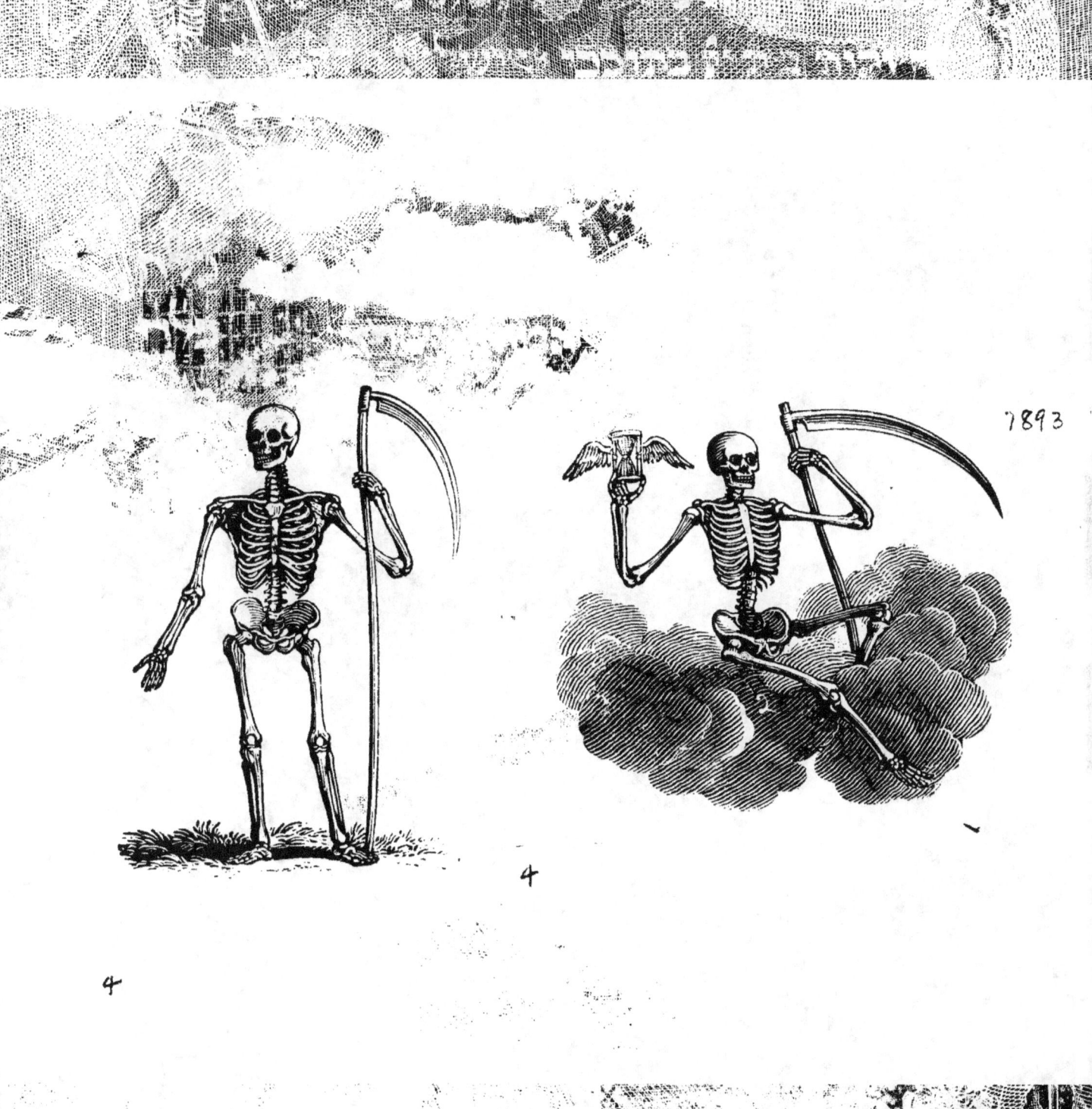

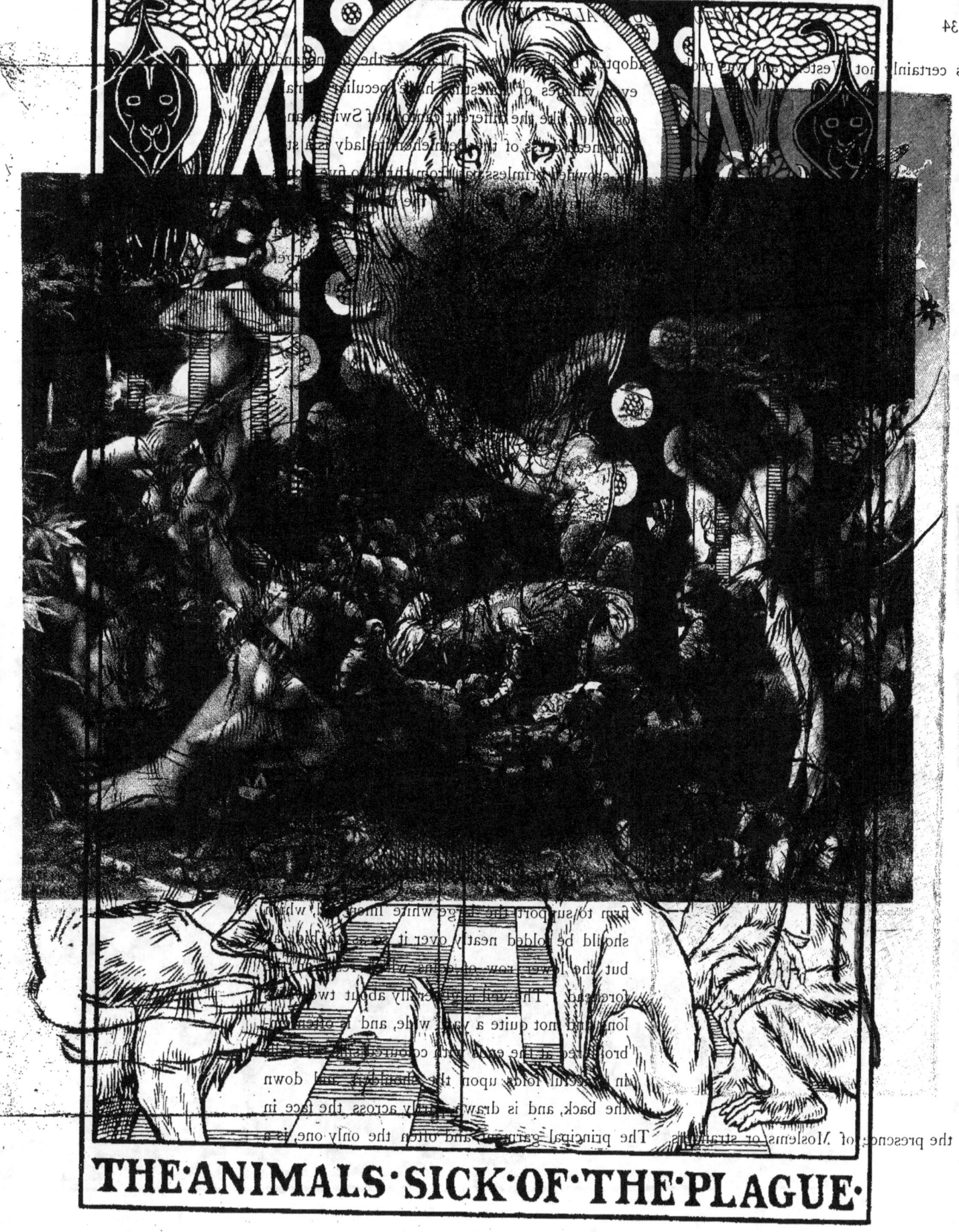

THE·ANIMALS·SICK·OF·THE·PLAGUE·

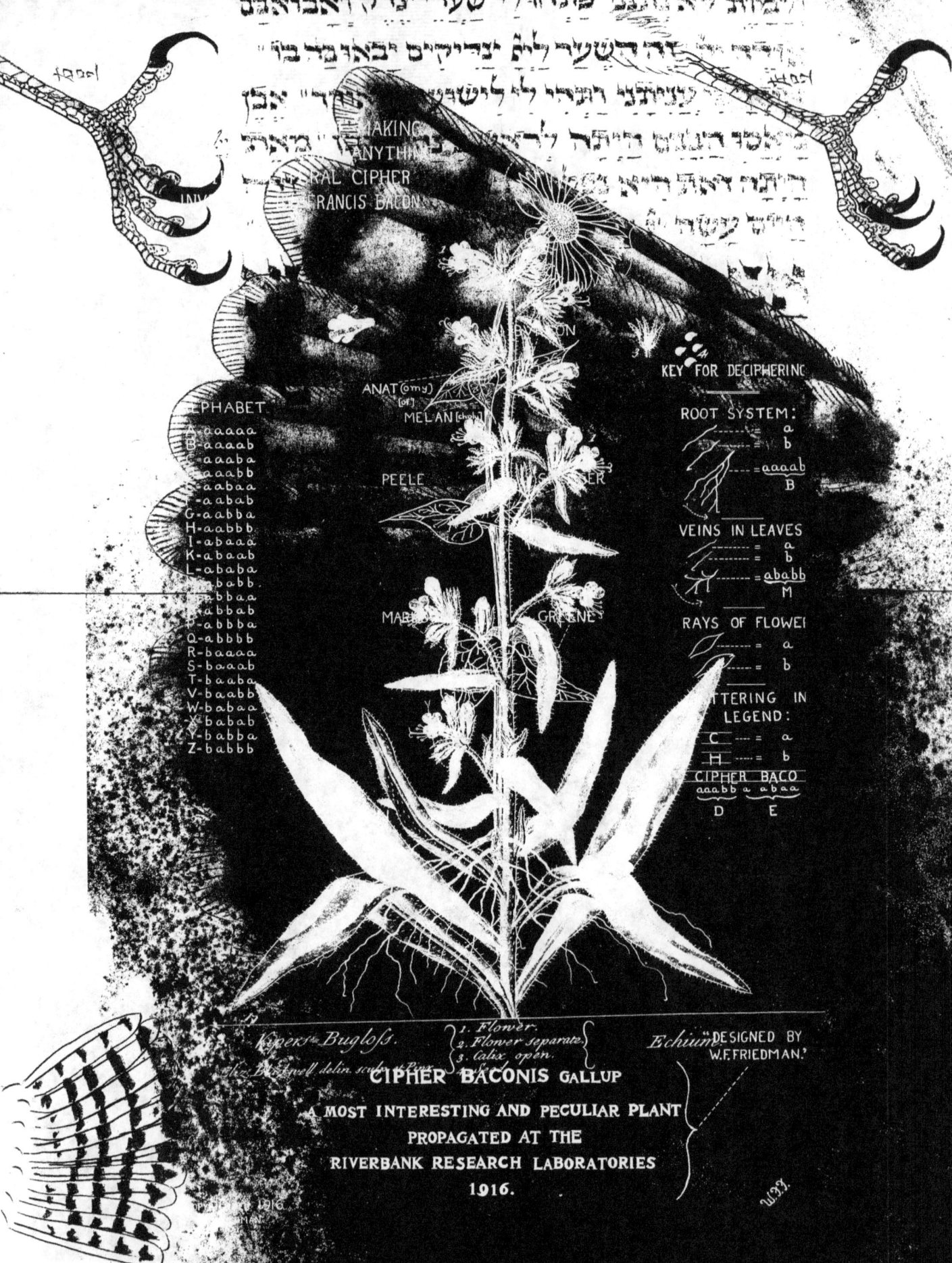

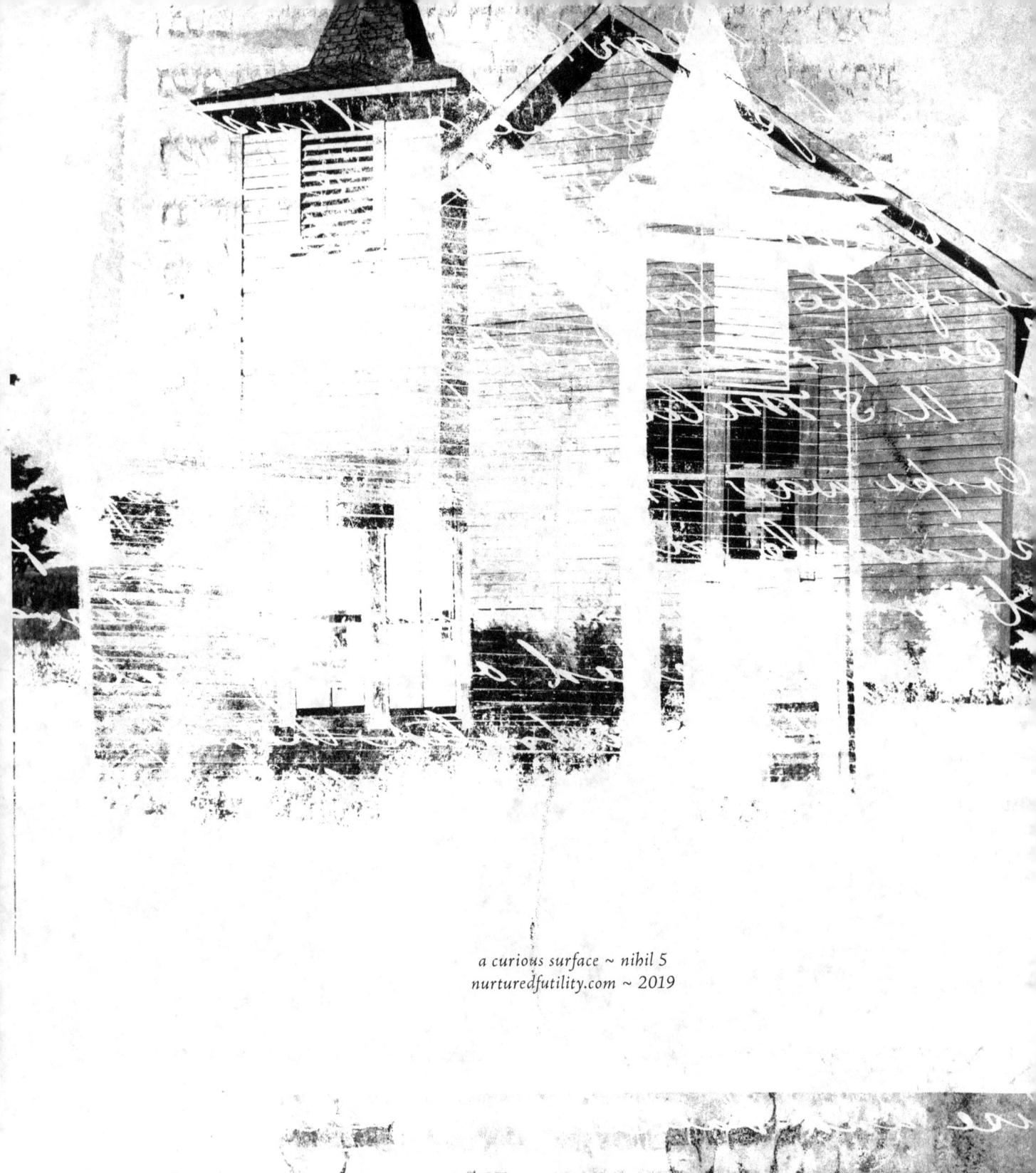

a curious surface ~ nihil 5
nurturedfutility.com ~ 2019